Jules Pascin

Text : Alexandre Dupouy
Page layout : Julien Depaulis
Translator : Chris Murray

© 2004, Parkstone Press Ltd, New York, USA

ISBN 1-85995-879-6
Printed in France

1. *Stein's Two Small Girls*, 1902,
 pencil drawing, 35 x 37.5 cm,
 Israel Museum, Jerusalem

Alexandre Dupouy

Jules Pascin

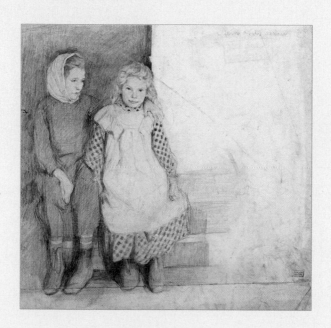

Dedicated to Guy Krogh and André Bay

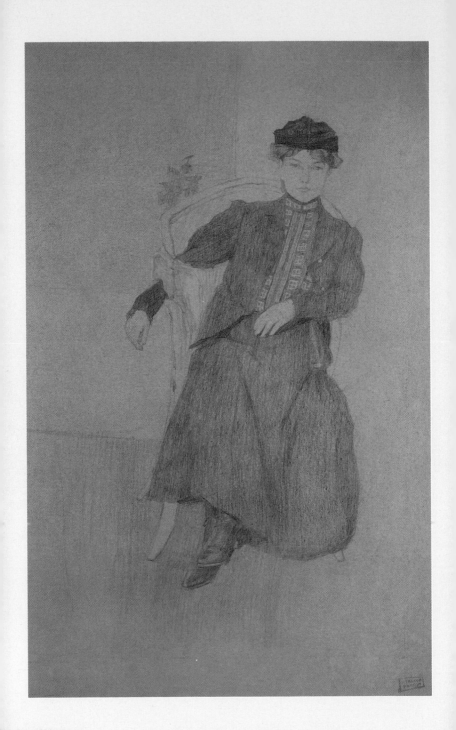

The Caliph and His Three-Hundred and Sixty-Seven Models

"…Don't go back like that… Continue to follow the body of poor Pascin. Yes, I'm leaving you. I'm staying here with the spirit of his image. I'm staying with the mystical Chagall—his delicate companion at his side, with Kisling and Papazoff who are of the same wonderful lineage, and with all of his dear friends and their reddened eyes. I'm staying with André Salmon and Marcel Sauvage, his face full of distress, with models of every color hair and race, even gallery owners, their sorrow tempered by the sharp rise in the value of his work worth his departure into eternity… Oh Zadkine, excuse me, as a sculptor you have the cult of material and the naked mortals that you follow with the hope for survival, for transfiguration, for 'that by which one finally changes eternity.' I see him again, haunted by flesh, by the hallucinations of desire, by spreading legs and obscene rumps of sprawling women, and by the wonderful and terrible call of the human being to which he responded triumphantly with his great and simple goodness."

—W. Mayr, *Souvenirs sur Pascin*

2. *The Young Girl from Munich*, 1903,
 black and yellow pencil drawing, 35.3 x 23 cm,
 gift of Mrs. Lucy Krogh in 1936, Museum of Modern Art, Paris

The scene is Paris on the seventh of June in 1930. The quivering restlessness of the new season momentarily holds still for an extraordinary event. This morning the curtains of the art galleries remain drawn as a somber and impressive funeral procession marked by heavy emotions slowly climbs through the streets of Montmartre towards the cemetery of Saint-Ouen. A thousand or so stunned mourners, their contorted faces streaked with tears, follow a frail horse-drawn hearse with heavy but silent footsteps. At the head of the procession is the noble and black silhouette of Lucy, the faithful and beloved mistress of twenty years. Lucy is the wife of Per Krogh, her cuckolded husband who waited in vain for her during the years of her tumultuous relationship with Pascin. Per is here as well. He does not hesitate to join the long procession and holds the arms of his grief-stricken wife while several women moved by his gesture congratulate him in silence.

3. *The Model at the Studio*, 1903,
 pencil drawing, 45 x 30 cm, Israel Museum, Jerusalem

Next pages:
4. *The Shepards*, 1903, watercolour,
 37 x 51 cm, collection of Mr. and Mrs. Abel Rambert

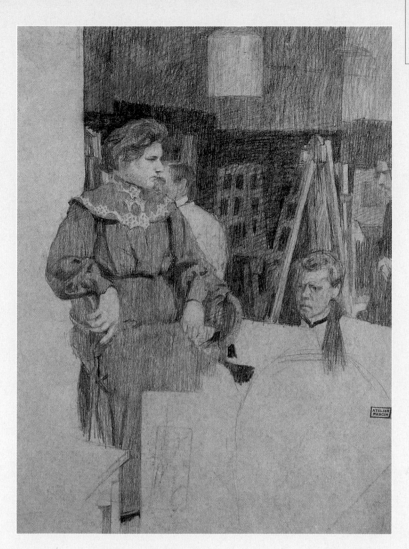

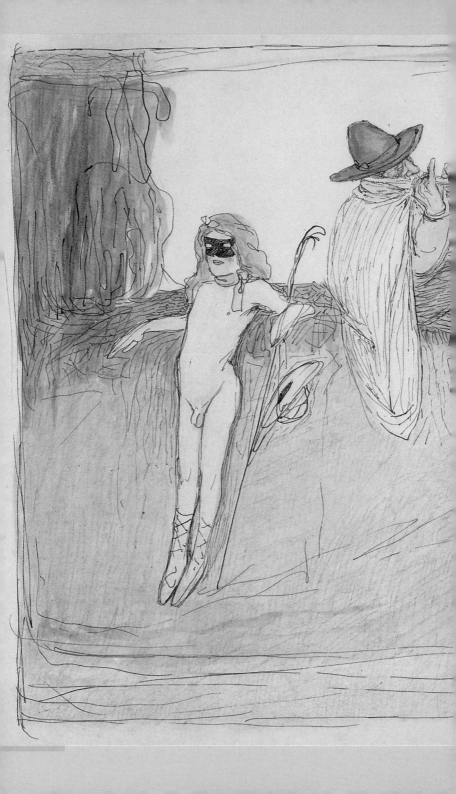

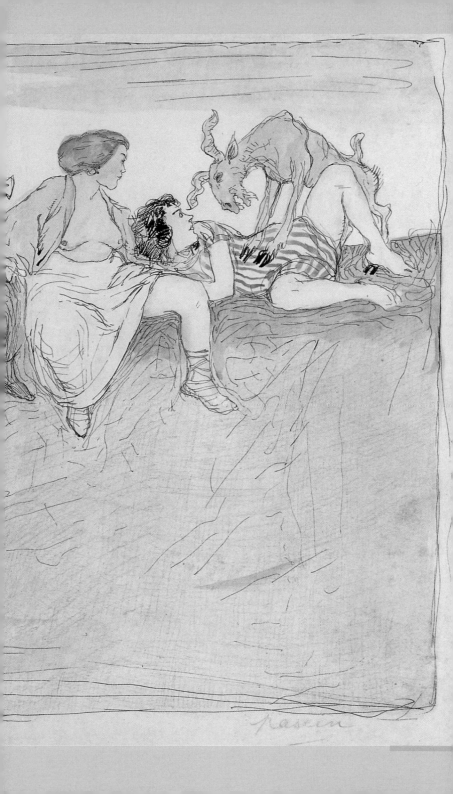

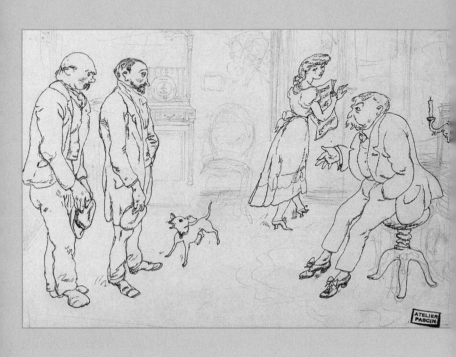

Behind Lucy is the family of close friends. Julie and Simone Luce, mother and daughter who were present at Pascin's side through thick and thin support Hermine, or, she supports them. Hermine is the legitimate widow—evanescent, tragic, and fragile. All of Montmartre and Montparnasse comes next. There is a host of his friends: painters, sculptors, writers, and editors. And after them come the models, dozens upon dozens of models, losing forever his good deeds and generosity, the tenderness of a lover, and a friend more than a mere employer. There are also the art dealers, interested in the man, in his work, in profit, or in all three. Next come a host of unknowns, the masses of Paris, tradesmen living on the fruit of their labor or their bodies, café owners, restaurateurs, paint sellers, carnies, hooligans, pimps and prostitutes. Finally, bringing up the rear there is an old well-groomed hobo delegated by the beggars of the Boulevard de Clichy to attend the funeral.

5. *Two Employees in front of the Boss*, 1906-1908,
 pen-and-ink drawing, 14.5 x 20 cm, Israel Museum, Jerusalem

They could not conceive of not following their unusual friend one last time. He was a friend who would greet them without shame, and sit among them on a park bench. A friend who knew their talk and their marvelous stories of distant countries. He would invite them to his house to laugh, drink wine and eat chicken, and do it all again the next day without paying heed to any difference in class or rank—so great was his immense humanity. In those early years of the twentieth century, what kind of man could bring about such a consensus? Who could be so missed by the public, with his departure creating such great emptiness? He was not a statesman, great thinker or a general. He was a painter and a sultan who would have felt at home in the *Thousand and One Nights*.

6. *Three Young Girls in a Room*, 1906-1908,
 pencil and wash drawing, 23.5 x 22 cm, Israel Museum, Jerusalem

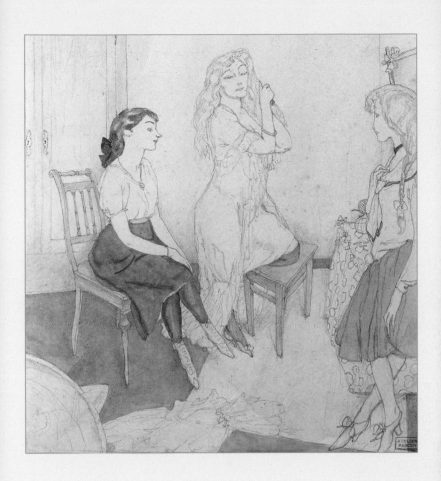

In 1885, America had not yet won its Indian Wars and the world was divided between East and West. Vidin, a little Bulgarian city on the banks of the Danube not far from the Romanian border lay in the middle. It was here on March 31 that Julius Mordecai Pincas came into the world, the seventh of nine children born to Sophie Pincas née Russo and Marcus Pincas. His father was a rich grain merchant, and both parents were descendants of Sephardic Jews who had fled the 15th century persecutions of the pious Queen Isabella's Spanish Inquisition. The family origins were lost in the cultural maze of the Balkan frontier among Bulgarians, Spaniards, Turks, Romanians, Serbs and Italians. One author even mentions an ancestor who was taught drawing by the young Rembrandt.[1] Pincas' close friends and biographers called him a "citizen of the world." Appropriately, Julius claimed nowhere in particular as his homeland, and in a sense, was from every country. It was to be the young nation of America, bearer of all hopes, that would eventually give him his official nationality.

From a young age, his father frightened him, ruling the family and household staff with primitive terror. A precocious draughtsman, the child reproduced his father on paper with all of the traits of Thumbelina's ogre. Marcus often whipped his servants and his sexual freedoms amongst them were commonplace. Later in life, Julius recounted to his friends the story of Moïse, a twenty-year-old employee of the house who hung himself upon learning that Marcus had raped his fiancée. Traumatized by his father's tyranny, Julius took refuge in the kitchen among the servants as well as in his drawings, where he exercised his imagination by illustrating fairy tales.

7. *Insolent Couple in a Waiting Room*, 1907-1908,
 watercolour, 26 x 17.5 cm, Israel Museum, Jerusalem

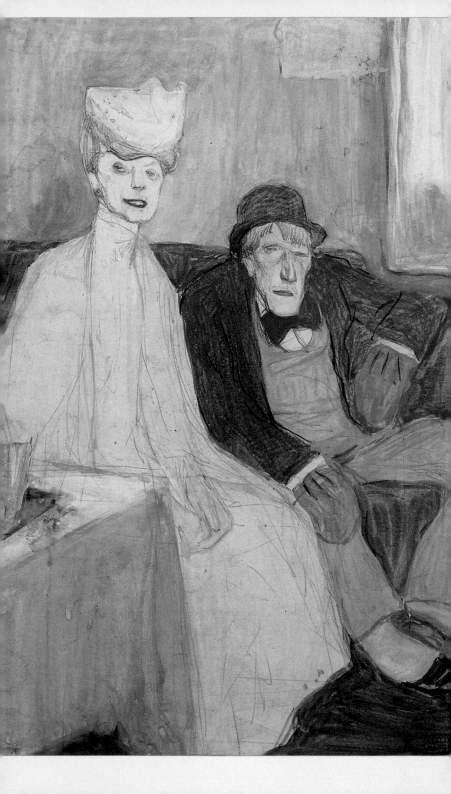

The boy's first erotic awakening occurred when he accompanied his aunts to the Turkish baths, where he discovered multitudes of lounging bodies that intrigued and fascinated him. Another seminal experience was his exchange with a young maid: her portrait for an inquisitive look at the treasures hidden beneath her skirts. Despite the consolations that he took from his friendships with the servants, Julius finally fled his familial house through a window after an unpleasant sojourn in a Viennese pension. The remarkable introduction to his first mistress Fanoriatal was to be more momentous for him than what had laid underneath the servant's skirts. He was sixteen; Fanoriatal was twice his age. He was of the Sephardic elite, she was of the Romanian aristocracy. Both preferred the excitement of a tumultuous life to that of constrained routine. She was also the head of one of Bucharest's most luxurious houses of ill repute.

The madam welcomed him like a prince and cherished him like a child prodigy. Julius, spoiled and thriving, drew continually with her encouragement. The girls of the house became his models in a privileged situation where the adolescent, served by Providence, was able to appease his fantasies and desires. Small and weakly, he did not seem predestined to such precocious love, but found himself in the bosom of a brothel and initiated to all of its vices. His drawings were successful. Some of them recalled the spirit of *Simplissimus*, a satirical review that was the era's Bavarian answer to France's *l'Assiette au beurre*. Europe had been moving towards acerbic caricature of the worst of bourgeois hypocrisy for many decades. The budding artist expedited some drawings to an immediate response. Beginning with his first submission, his work was published. *Simplissimus* director Albert Langen invited him to join the exclusive circle of collaborators at the review.

8. *The Sad Girl*, 1908, watercolour, 15 x 23 cm,
 Israel Museum, Jerusalem

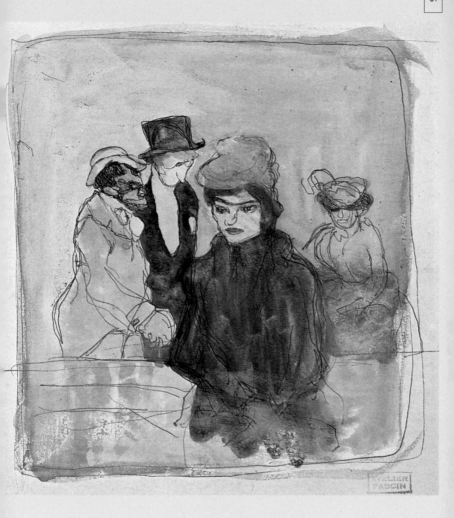

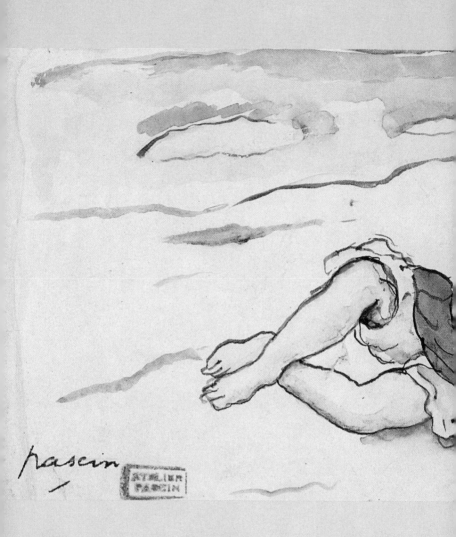

9. *Two Small Girls*, 1908, watercolour,
 11 x 21.5 cm, collection of Mr. and Mrs. Abel Rambert

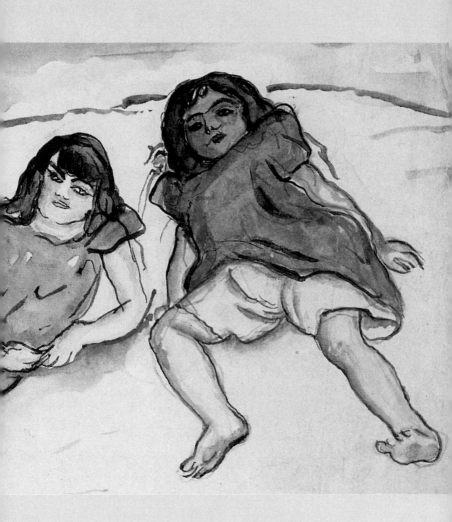

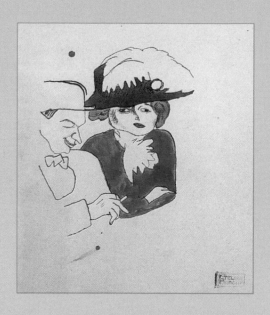

In March of 1905 Julius left Bucharest for Munich, the cosmopolitan capital of Bavaria and seat of the reactionary Prussian government. His father intervened—Julius could not remain a Pincas. His grandfather, the consul of Austria on the Danube, had transformed the family name from Pinas into Pincas to lend it better sonority. Julius obeyed his father's desire, suppressing his first name and rearranging the letters of Pincas, ever afterwards signing his name Pascin (pronounced Pass-keen) with a upper case "p."

Like most of the artists of his time, the young Pascin submitted to the attraction of the "city of light" bathed in the colours of the Impressionists and Fauves that were appearing on the palettes of French painters. He joined the eclectic entourage of Paris on Christmas Eve of 1905. But Pascin did not descend from the Orient Express a lonely

10. *Couple*, 1908-1910, pen-and-ink and watercolour drawing,
 14.5 x 16 cm, Israel Museum, Jerusalem

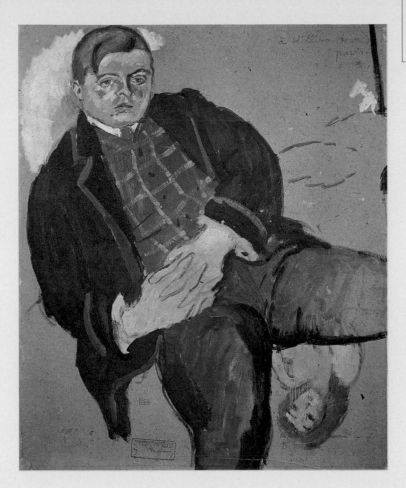

immigrant in the snow. His reputation had preceded him, and a veritable international delegation of painters and personalities were waiting for him. It was the Ecole de Paris which, as it was emerging, welcomed one of its future masters, though his art would remain difficult to classify.

11. *Portrait of William Howard*, 1909,
 oil on cardboard, 55 x 46 cm, Israel Museum, Jerusalem

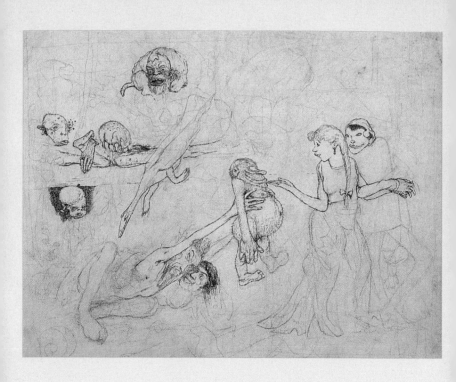

Nevertheless, let us accept the proposition of the critic Florence Fels who affirms that "The place in the cast of the Ecole de Paris that belongs to Pascin corresponds to the place of Renoir in Impressionism and that of Toulouse-Lautrec in Neo-realism."[2] From the Gare de l'Est, the procession crossed Paris en route to the Café du Dôme and its bohemian universe that Pascin would remain a part of for the rest of his life. "In the space of an hour he paid for one person's taxi, the drinks of another, and the tobacco of a third."[3]

12. *Grotesque Figures*, 1910,
 pen-and-ink and pencil drawing, 39 x 39 cm,
 Israel Museum, Jerusalem

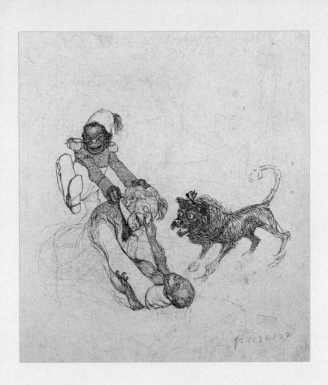

They all carried him triumphantly. Bacchus had arrived and the infernal
bacchanal of the Trois Monts (Montparnasse, Montmartre, and Mont de
Vénus) began. The orgy would only be snuffed with his death.

After having lived for some time in the hôtels of Montparnasse, Pascin
moved in with Henri Bing, one of the "Dômiers" that he had met in
Germany. One September morning in 1907 there came a knock at the
door. It was Hermine David, who had come to show them her 18th
century-style miniatures that she painted on ivory.

13. *The Fight*, 1910,
 pen-and-ink drawing, 32 x 23.5 cm,
 Israel Museum, Jerusalem

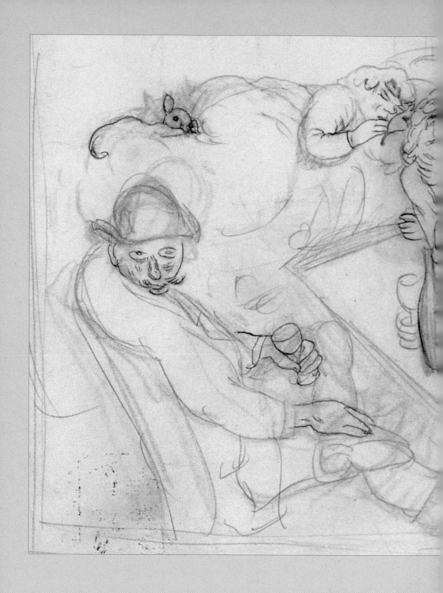

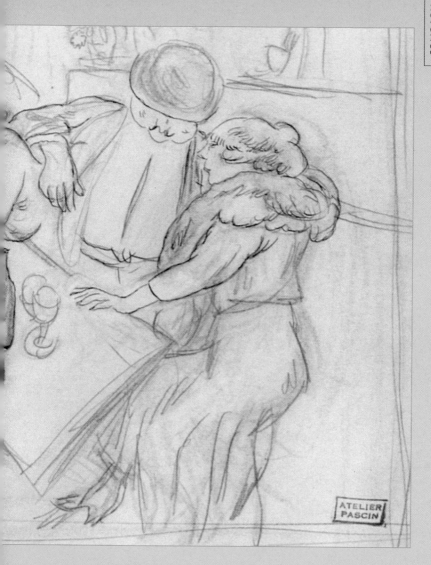

14. *The Drinkers*, 1910,
 pen-and-ink and pencil drawing,
 17 x 26 cm, Israel Museum, Jerusalem

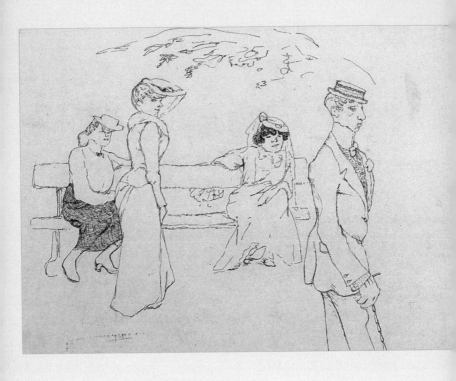

There was a bawdy legend about the young Hermine. Her mother, a woman of a more conservative generation, was a seamstress who sewed undergarments to protect her daughter's virginity, wielding her needle and thread like a chastity belt. The two overexcited young men hoped to determine the fate of the despotic mother's needlework. After a friendly conversation, Hermine's obvious interest in Pascin caused Bing's interest to efface itself. The mother's stitches were no match for the young Pascin's agile fingers, and aided by the lascivious complicity of Hermine, the first bloom of a long and tumultuous relationship was born. By the time Hermine's mother learned of the demise of her needlework there was little she could do, and the artistic couple moved in together in Montmartre. Not content with his drawings, Pascin tried his hand at painting. Hermine encouraged him and often served as his model. He painted in the style of the Fauves with thick layers of paint, in contrast to the pearly and evanescent washes that would mark his later successes. In searching for inspiration, Pascin visited the Louvre where he was arrested by the sensuality and elegant happiness in the works of the 18th-century masters Watteau, Boucher, and Fragonard. In 1910 Pascin's paintings were exhibited at Berthe Weill's gallery to little reception. However, his drawings were being hailed as some of the best of their time on the other side of the Rhine. They took after the work of Lautrec and anticipated that of Brassaï and his depictions of the dregs of society inspired by his memories, his surroundings, and his nocturnal outings in the sordid neighbourhoods of Paris were favorites of the Bavarian readers. These sources of inspiration were not without their dangers. Pascin received his share of razor wounds and bruises that greatly worried Hermine. He fought like a fearless street tough and despite his sensitive and fragile side he held a public air of defiance that always followed his trail of excess.

15. *The Dandy and the Three Women*,
 1910-1912, pen-and-ink drawing, 20.5 x 24 cm,
 Israel Museum, Jerusalem

Pascin's monthly payments from *Simplissimus* and the sale of drawings and portraits allowed him to earn a comfortable living. The cruelly sharp-witted style of the early drawings for the review gradually disappeared in the wake of a new hand that was more free, elegant, gracious and supple. His characters developed, bearing the allegresse of subtle melancholy, rather than the hideous rictus of his earlier sarcastic caricatures.

The young artistic couple lived in a very open relationship. Hermine was well aware of Pascin's affairs. His infatuation with the female sex ranged from young girls to prostitutes. She was not afraid of them and was not strict with him. Their relationship and their complicity, lay elsewhere and allowed for their eccentricities. She consented to his fantasies that mirrored the tales of Sheherazade. After all, a grand Caliph of legend would certainly lie with two wives and a concubine every day of the year. And it seemed that all were satisfied by the situation.

Pascin met his "second wife" in Montparnasse. Like Julius Pincas, Cécile Vidil had fled to Montparnasse to escape a reproachful family. Her reason was a failed exam and the desire to escape the family bakery in the town of Issy-les-Moulineaux. She may have also simply wanted to discover the vast offerings of the world. Her mother was Swiss-German, and her father was from the Auvergne region. She had three brothers and two sisters. Suspecting that her parents would come after her, Cécile hid herself in a little hôtel on the Rue Delambre two steps from the Café du Dôme and changed her name to Lucy. Albert Marquet noticed this "splendid girl" and struck up a conversation with her as she was leaving her lodgings.

16. *Seated Young Italian*, 1912,
 gouache on cardboard, 46 x 38 cm,
 Museum of Modern Art, Paris

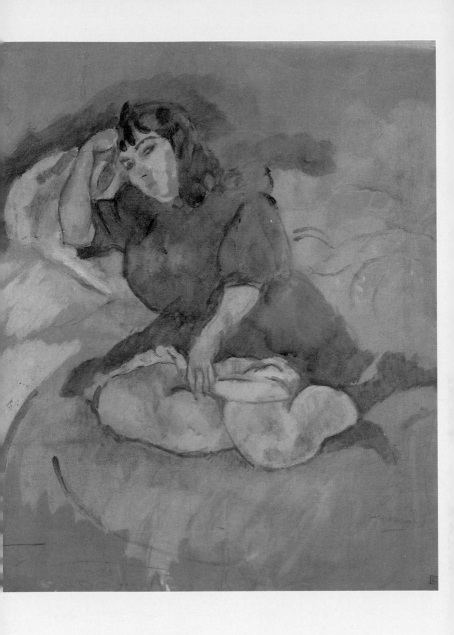

She complained of having no money and of not being able to find work. The painter advised her to pose for the Académie Matisse on the other side of the boulevard. There she discovered the liberated world of artists and the seductive idea of easily earned money. She innocently imagined the young and handsome artists who wanted to paint her portrait. She moved out onto the street with a light step that gently bounced the cherries ornamenting her hat.

Lucy quickly became disillusioned. The students were indeed young, but not all were handsome. In addition, she was not to pose for a portrait. "Well then, Mademoiselle, please go ahead and disrobe." Lucy was confused but she obeyed. She hid behind a screen and delicately folded her clothes, reappearing nude before the young men in all the freshness of her eighteen years. Pencils fell from their owner's hands. All of the men stood amazed and open-mouthed, and all of the men desired her. Her entry into artistic and cosmopolitan Montparnasse was the stuff of legend. From then on, she was always on the minds of two painters: Per Krogh the Scandinavian and Pascin the Easterner. It is certain that Per was at the Académie Matisse, as he attended class religiously. Pascin, however, found the teacher too opposed to his own convictions regarding painting and women. Matisse was a materialist, unlike the sensualist Pascin who was convinced he could never simply paint a woman as one would an apple. It is not clear exactly when he met her, perhaps it was later at the Café du Dôme. From this period on, Lucy frequently posed for drawings and became one of his ninety-five lovers. It was not until much later that she achieved the supreme state of becoming the painter's special passion.

17. *Seated Woman*, 1912,
 oil on canvas, 73 x 60 cm,
 Israel Museum, Jerusalem

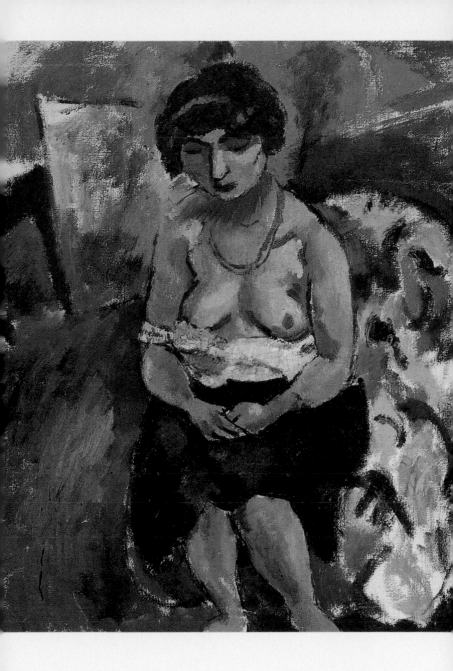

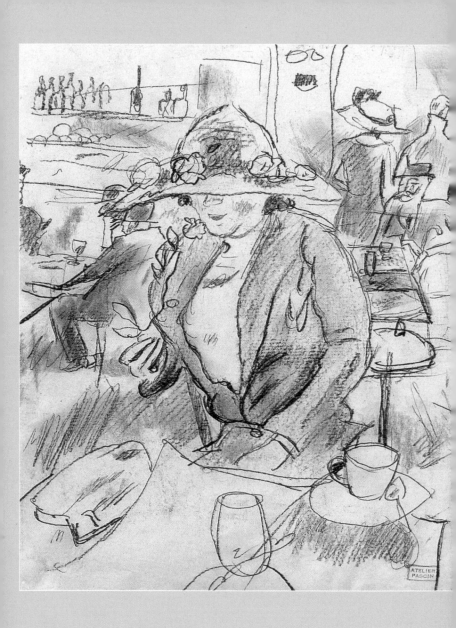

The young emancipated woman wanted to take full advantage of her eventful life in Montparnasse. She found lodging in the house of the clothier Jeanne Lanvin that allowed her a certain degree of freedom and ease. She responded warmly to Krogh's advances. Together, they formed a stage duo with a repertoire of French chansons and contemporary dances, primarily the tango. Starting in 1911 they appeared regularly in Per's native city of Oslo.

Pascin divided his artistic activity between his portraits, his nudes, and his illustrations of Montmartre's seedier side. Hermine became more and more concerned about his frequenting of the neighbourhood's dives and attempted to divert his interests by moving first to the Avenue des Ternes and then again in February of 1914 to 3 Rue Joseph-Bara to a superb studio not far from the Café du Dôme and the académies. Pascin's keen intelligence and global vision sensed the inevitability of the most terrifying war that humanity had known. If he had respected the alliances concluded between the European states, he would have joined the Bulgarian army to fight on the side of the Germans. The alternative was becoming a French prisoner. He and Hermine did not wait for the war to begin, and left for New York City via Brussels and London in June of 1914.

For some unknown reason, perhaps out of concern for her mother or a fear of sailing, Hermine returned to Paris leaving Pascin to cross the Atlantic alone. Upon his arrival, the immigrant artist installed himself in a Jewish neighbourhood of Brooklyn. He never had felt especially Jewish, particularly when among those with the same heritage, where he felt there was too much fuss over morals and religion. He greatly preferred the company he found in black Harlem where it was acceptable to talk loudly, dance, sing, and live life to the fullest in spite of miserable conditions.

18. *Woman in a Café*, 1912-1914,
 pencil and pastel drawing, 27 x 22.5 cm
 Israel Museum, Jerusalem

Max Weber and Maurice Sterne were two "Dômiers" who had immigrated before Pascin. They guided the little elegant white man through the Harlem streets that welcomed him like a king. Pascin's art flourished. He was quickly recognized and adulated, and it seemed that he should found an académie to promote his marvelous style. But once again, he wished to remain unconstrained by allegiance to any movement. His drawings were gradually liberated from the morbid mannerisms imposed by *Simplissimus*. His lines simplified and became cleaner. His chosen subjects crackled with life, even when he drew seated on the ground, his notebook on his knees. For his own amusement and that of his artist friends, he even threw together some cubist paintings, the greater part of which he later destroyed.

Hermine joined Pascin after a separation of six months. Her fear of sailing had been well founded for she had been sick for the entire duration of her crossing. Pascin loved New York's cosmopolitanism and its diverse neighbourhoods—Italian, Chinese, Indian, black, and Russian, all of humanity concentrated and assembled on a few thousand acres. Life was much as it had been in Paris—love and work during the day, and then the night spent in the underworld with its parade of squalor and dangers dreaded by Hermine. She would occasionally take pleasure in joining his bohemian drinking sessions.

19. *Hermine David*, 1915,
 pen-and-ink and watercolour drawing,
 21.5 x 32 cm, Israel Museum, Jerusalem

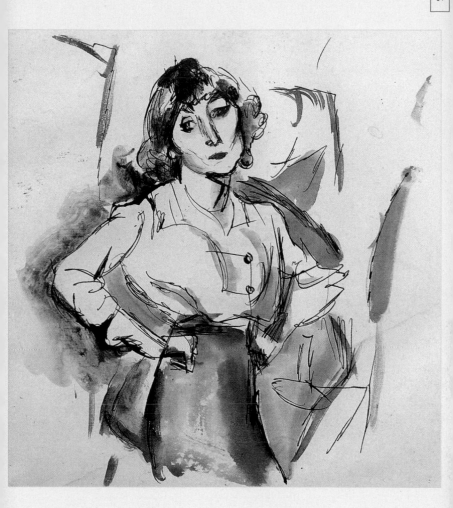

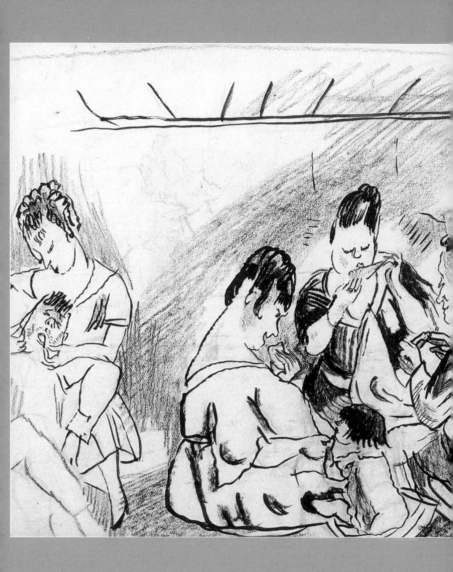

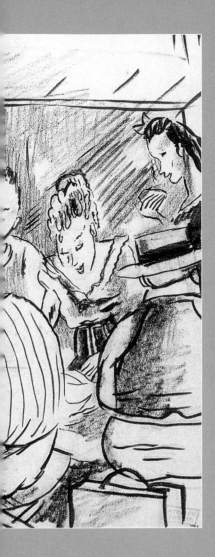

Pascin seized the abundance of marvels at hand in the New World. He wanted to see, discover, and sketch everything. He decided to make an artistic voyage following the footsteps of the painter-travelers of the past, Delacroix and Vivant-Denon. The couple left together, carrying their own baggage and everything that they would need: watercolours, inks, pencils, and paper. Pascin had distaste for luxury and grand places, and they traveled humbly. Guided by curiosity, they went to Virginia, passing through Washington before stopping in Charleston.

20. *The Picnic*, 1916-1918,
 pen-and-ink and pastel drawing,
 21 x 30 cm, Israel Museum, Jerusalem

They visited the surrounding countryside beyond the cities—the deserted beaches of South Carolina, vast plains and forests full of strange sounds and shadowy phantoms. Everywhere they went they sketched, drew, and painted watercolours side by side. They stayed for a few days in a welcoming town and witnessed a service in a black church where the people raised their joyous voices with great emotion and tearful eyes. Sadly, a deadly hurricane caused them to leave Charleston, to flee its destructive path. Pascin dreamed of continuing through Florida towards Cuba, but it was too many boats for Hermine who did not wish to relive the hell of her Atlantic crossing.

It was time for them to take stock of their work and to compare their results. As it often is with artistic couples, the work of one tints the tone of the other. Their regular analysis of the advancement of the quality of their work and their mutual criticisms and congratulations allowed them to see how their traits influenced each other, drew together and began to resemble one another. The couple pondered with gravity and affection how they could help to conserve their own personalities.

21. *Landscape with Palm Trees*, 1916-1918,
 pencil and wash drawing, 22 x 29.5 cm,
 Israel Museum, Jerusalem

Next pages:
22. *Faubourg of Havana*, 1917,
 pencil and watercolour drawing,
 20.7 x 29 cm, private collection

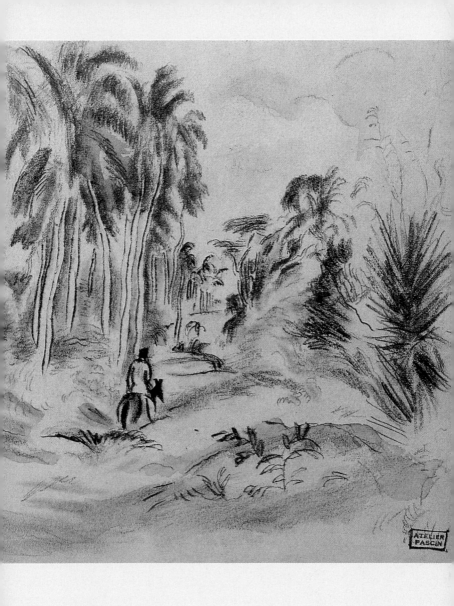

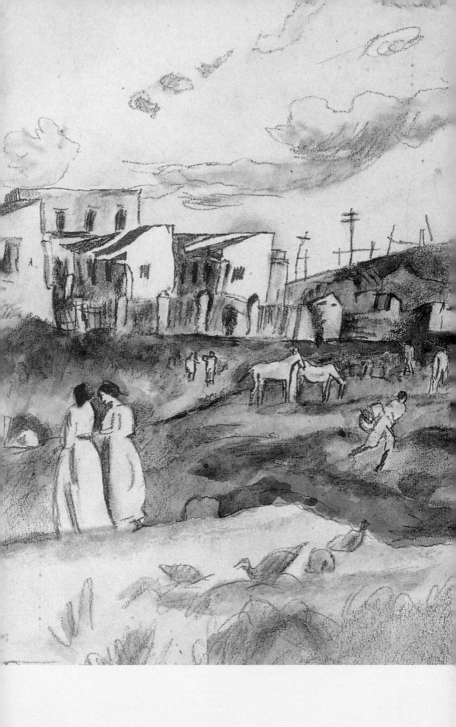

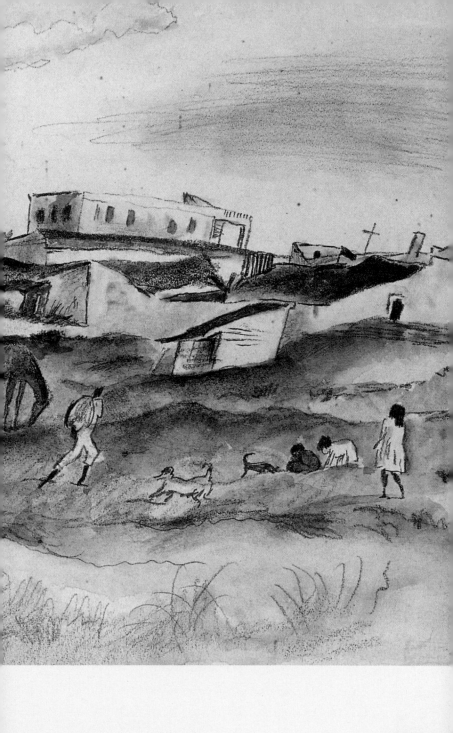

Instinctively, Hermine gave great care to her landscapes and the figures of Pascin were full of charm and endowed with a vibrant and alert sense of life—so it was, that they separated and adopted a contract to which they would hold for the rest of their lives. "Hermine takes the landscapes, I do the figures." It was a determined decision that demonstrated part of Hermine's importance at the side of Pascin—to his work and their complicity. She was certainly the one artist to whom Pascin felt the closest. The other part of that irrevocable decision meant that after the couple's trips through America, the public would not see another canvas or watercolor of a landscape by Pascin's hand. The man was complete, and his work held to the terms of their agreement.

So Pascin continued south alone through Palm Beach, Miami, and crossing the Atlantic to Cuba. Havana was far from the days of Castro then, and it was a glittering city akin to Las Vegas and given over to the pleasures of the flesh, drink, cigars and gambling. Pascin spent many weeks there before returning to New York with his bags stuffed full of drawings. The news of the war in Europe was bad. In April of 1917, the U.S. decided to enter the conflict. Pascin was well aware of the reasons that had forced him to leave the continent and did not regret his departure, but the memory of his friends left behind haunted him. He wondered where they were and if they were still living. He did not know if they had been imprisoned, or if the Dômiers were still at the Dôme or in the trenches. Had Georges Grosz killed Moïse Kisling?

23. *Street Scenes in Havana*, 1917,
 soft lead pencil, 23 x 27.5 cm, Israel Museum, Jerusalem

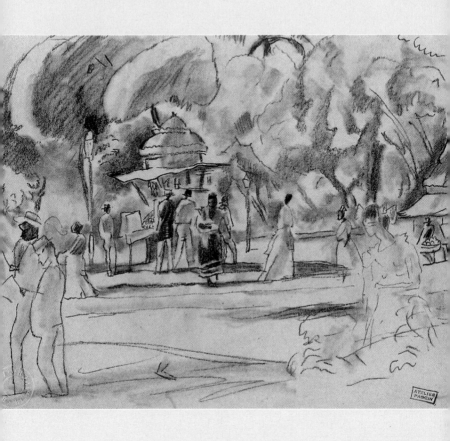

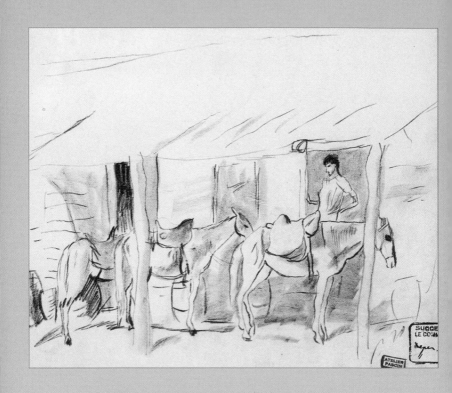

Faced with these questions he often made inquiries that rarely had any result. By a miracle he discovered Kisling's location. Mac-Orlan recounted Kisling's story years later.

"When we relived our memories of Camblain-l'Abbe, Kisling told me he had not had a penny in his pocket. He wandered across the billet unable to go to any of the cafés. There were a few of us like that, living

24. *Horses in Front of the Stable*, 1917,
 black chalk, 28 x 32 cm, Israel Museum, Jerusalem

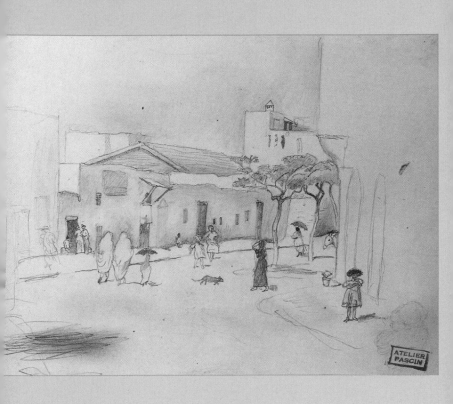

on the margins of the rest. One day, the postmaster asked him, 'Do you have princes in your family?' Kisling didn't understand, and then the postmaster gave him a money order for a thousand francs that had come from America. Pascin had surmounted the discouraging difficulties in finding Kisling's location and had reached him with that staggering sum."[4]

25. *Village in Tunisia*, 1924,
 pencil drawing, 13.5 x 18 cm
 Israel Museum, Jerusalem

Next pages:
26. *Street Scenes in a State in the South*, 1917,
 watercolour, 24 x 29 cm, Israel Museum, Jerusalem

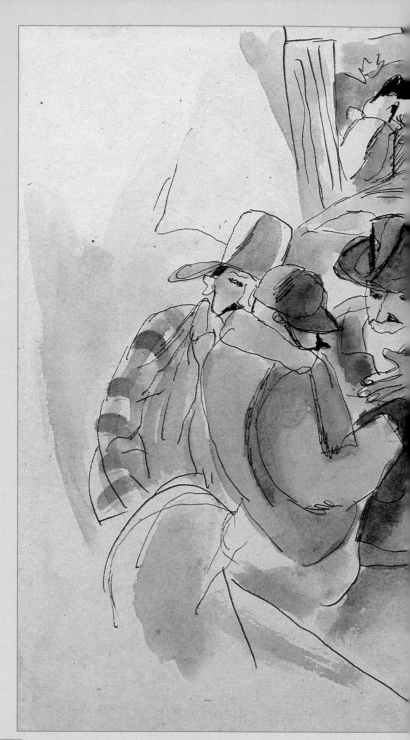

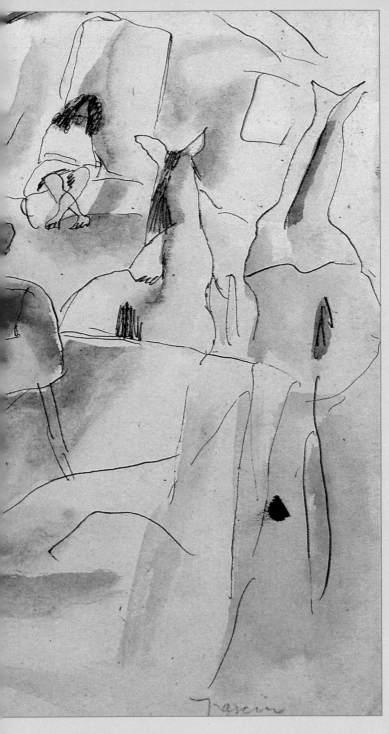

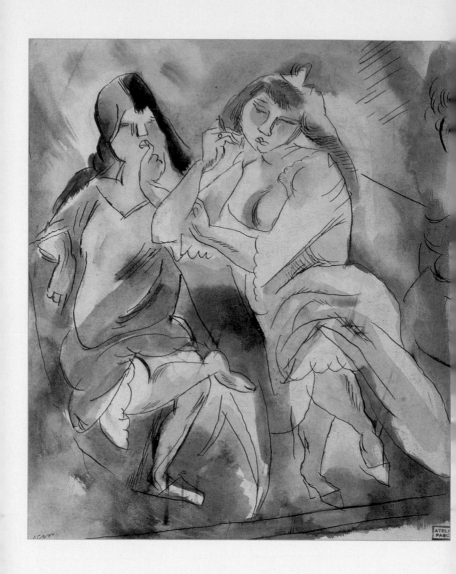

Per Krogh was in Paris. Pascin corresponded regularly with him and Lucy who were living in his studio at 3 Rue Joseph-Bara. The Kroghs had been married and had a son. Pascin and Hermine remained unmarried and childless by choice. Pascin's thirst for freedom caused him to condemn marriage. He saw little difference between married or unmarried life, and if they had married, it would have been for Hermine's happiness, not to silence the puritan sarcasms some people used to refer to their illegitimate union.

As if to finally bury Pascin's bachelorhood, Pop Hart, a talented watercolour painter fifteen years his elder invited Pascin to New Orleans for Mardi Gras to see the city, the carnival and its excitement, the houses with carved wood balconies and the doorless brothels vomiting forth their resident prostitutes onto Bourbon Street. The bars also opened onto the streets and each offered a faint murmur of the music that filled the French Quarter.

Hermine stayed in New York, and with Pop's return, she was reunited with Pascin. The two artists' stay together prolonged itself serenely as they worked side by side once again. With the end of 1918 came two important events. Hermine and Jules married each other on the 25th of September and the armistice was signed two months later. However they did not feel pressed to leave the New World and its riches. Hermine dreaded their return to Paris, and as far as Pascin was concerned, his paintings were selling and he wanted to keep travelling. He returned to Cuba and convinced her to face the crossing with him.

27. *Two Creoles*, 1917, pen-and-ink and watercolour drawing,
25.7 x 22.5 cm, gift of Mrs. Lucy Krogh in 1936,
Museum of Modern Art, Paris

Finally they returned to France after Pascin received his American citizenship on September 20th, 1920. In going to retrieve a trunk of drawings at his studio on Rue Joseph-Bara, Pascin found a Lucy radiant in her motherhood. They felt a mutual and overwhelming passion for each other to which Lucy succumbed. Afterwards, they saw one another regularly, at first clandestinely in hotel rooms, and after awhile more publicly with less and less restriction. Lucy assisted Pascin, she encouraged him and kept his books, bought his materials and found him models. Hermine and Pascin took a studio—each with their own side. Hermine discreetly let out her place to Lucy, consecrating herself to her work as an illustrator. Hermine did not disappear from Pascin's life. Pascin was able to love and keep two women—two women living with full knowledge of the other's existence, respecting one another and even becoming friends. Hermine and Lucy accepted the situation and remained friendly until and after Pascin's death. When there were no models to be found, he painted them together, relaxed in repose. Despite the burned bridges that lay between him and his family, and his subsistence upon his paychecks from *Simplissimus*, Pascin never suffered from want for money—but it fairly burned a hole in his pocket. For the next six years, when he was not travelling in foreign countries, Jules mixed work and pleasure. Sporting a black bowler à la Charlie Chaplin and a white scarf, he led a trailing bacchanal of friends from all walks of life who aided him in spending his money. "La bande à Pascin" consisted of other artists, writers, journalists, and other men like him, but also those of the underworld: prize fighters, animal trainers, homeless men found on park benches, boys from the neighbourhood and merry prostitutes, friendly pimps and criminals whom he might know a little bit, or not at all.

28. *Portrait of Hermine David*, 1918,
 oil on canvas, 66 x 50 cm, Israel Museum, Jerusalem

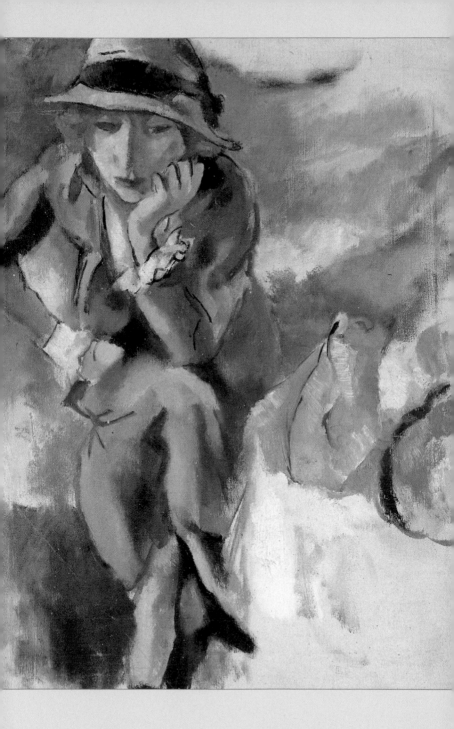

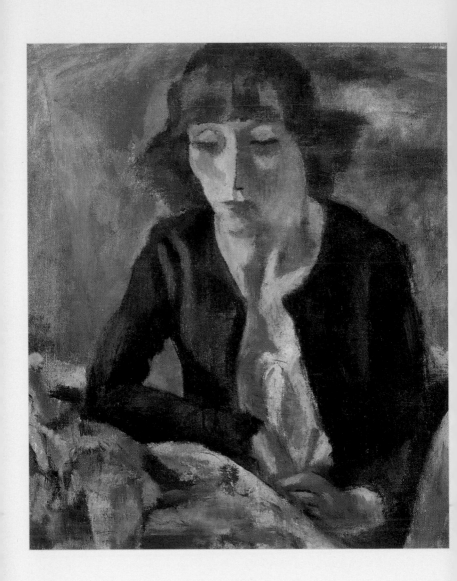

Pascin's daily surroundings included establishments with varying degrees notoriety: La Maison Rouge—just steps from his apartment on the Boulevard de Clichy, Le Rat-mort, L'Abbaye de Thélème, Le Cyrano—where he found some of his models, Le Jockey—the home of Kiki de Montparnasse. The worst was Les Belles Poules, a rough café frequented by barhopping soldiers and sailors. The end of the list was his open and spacious studio that was transformed by the immodest and long stays of its female occupants into more of a seraglio than a bordello.

At 36 Boulevard de Clichy, the red carpet ended at the fifth floor, for its length only protected the staircases of the bourgeois who dwelt below. Indeed, it was a feeble compensation for those occupants who lived so painfully close to the exuberant artists of the sixth floor. Below the attics, the immense studio with its high ceilings created an impression of emptiness. There was little furniture, an easel, a printing-press, piles of painted and unpainted canvasses jumbled against one another along the bare walls, and a monstrous accumulation of drawings overflowing from an enormous trunk slid into the closet under the stairs.

Pascin was incapable of making his studio double as a habitable space. He loved the interiors of his friends' apartments, but he could not settle down, truly living only in bars. His studio was a place for working and creating, it was a place of pleasure and repose—everything but a bourgeois interior.

Pascin was not sedentary and did not care to become so. He did not have a housekeeper, but he formed a working friendship with Julie Luce, a woman from Martinique who lived in Montmartre and served as a model, nanny, and a steward for daily activities as well as more festive ones.

29. *Portrait of Hermine David*, 1918, oil on canvas, 51 x 43 cm,
 gift of Mrs. Hermine David and Mrs. Lucy Krogh in 1936,
 MNAM-CCI, Georges-Pompidou Centre, Paris

Next pages:
30. *Women*, 1918-1920, watercolour,
 33.5 x 46.5 cm, Israel Museum, Jerusalem

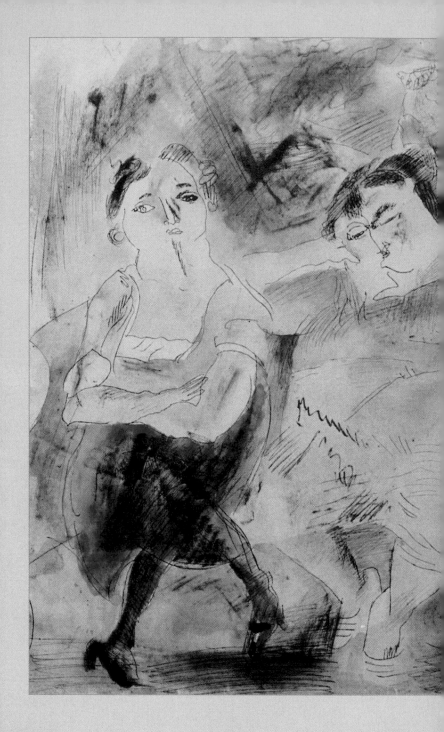

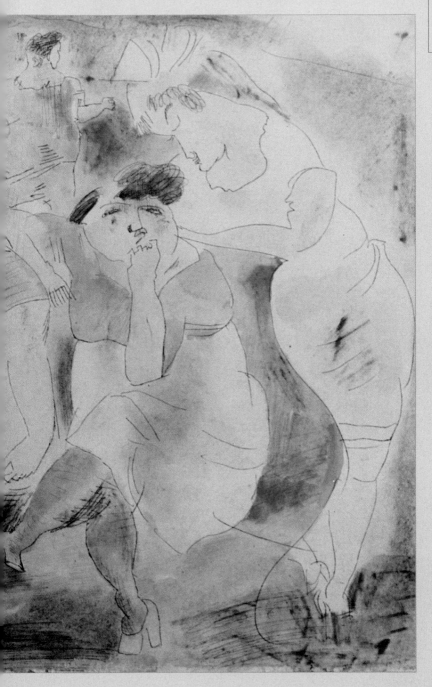

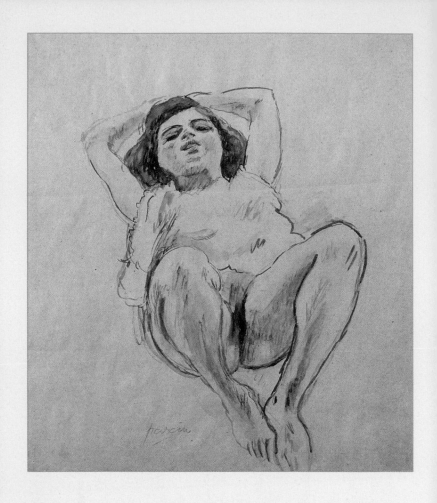

When she was not busy with the needs of Pascin and his household, she worked as an actress in films, theatres, and dance halls. Julie's daughter Simone always accompanied her and shared the careers of her mother: actress, model and steward. As she grew up, Simone became more and more attached to Lucy and took care of her son Guy regularly.

31. *Girl Lying Down*, 1920, watercolour,
 29 x 26 cm, Israel Museum, Jerusalem

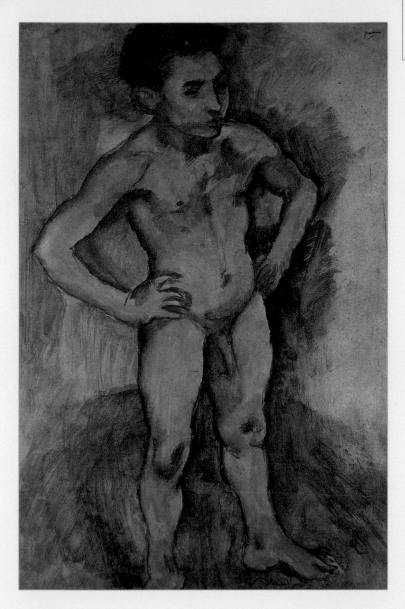

32. *Italian Model*, 1923,
 oil on cardboard, 76 x 53 cm,
 private collection, Paris

When Pascin would become worn out
by the tyrannical control of the Luce
women and their *"cour rapprochée"*, he
would call them his "step mothers."
A day in Pascin's studio did not begin
with the sound of an alarm clock. (The
cursed object ended up in the oven along
with its fellow creatures.) Like all artists,
a painter must practice his art daily. The
foundation of painting is the body,
anatomy, and the nude. In the schools
and academies, artists learned to draw
and paint with the nude. It was necessary
for Pascin to work from a model every
day, and to change models regularly.

When the artist wakes up in the morning
he wonders what he will do, for it is
necessary to find something to do.
This need to be occupied by something
is part of the human mechanism of the
painter. Of course, it is ideal to have a
model that comes every day, but it is not
always possible to pay a model. So, the
artist resorts to the objects he finds around the house, and to his friends,
hence the source of most portraits.
He may choose an apple, an orange, or an old drawing to work from.
"I could make something of this," the painter reflects as he leafs

33. *Girl Lying down on Her Side*, 1923-1924,
 pen-and-ink and wash drawing, 38.5 x 54 cm,
 Israel Museum, Jerusalem

Next pages:
34. *At the Goulette*, 1924, oil on canvas,
 73 x 91 cm, collection of Mr. Bernard Dukan, Paris

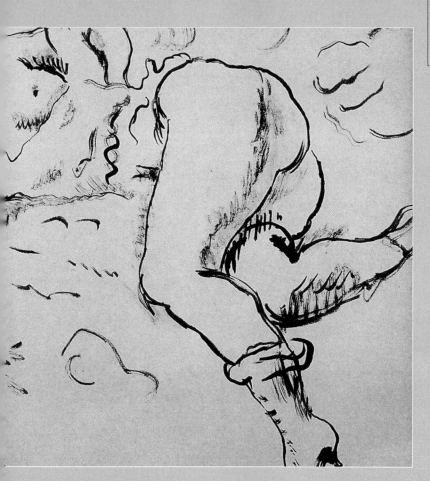

through his book of drawings. At the beginning Pascin had often used
Hermine, aside from the drawings destined for *Simplissimus*, or those he
sketched for his own amusement. With the drawings of Pascin, it is
necessary to differentiate between his two methods of working.

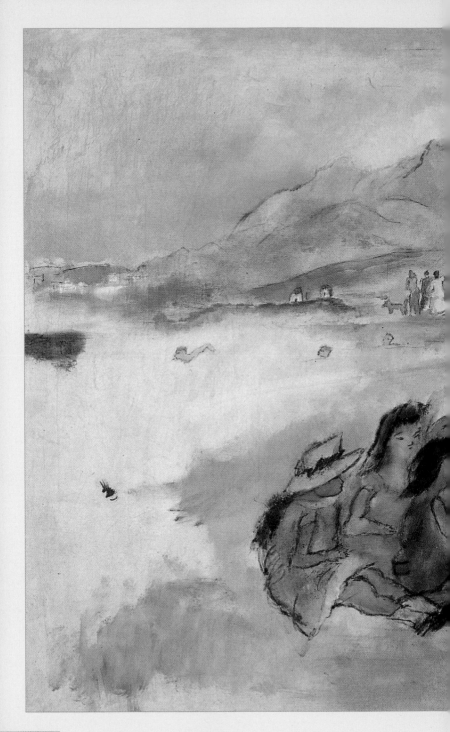

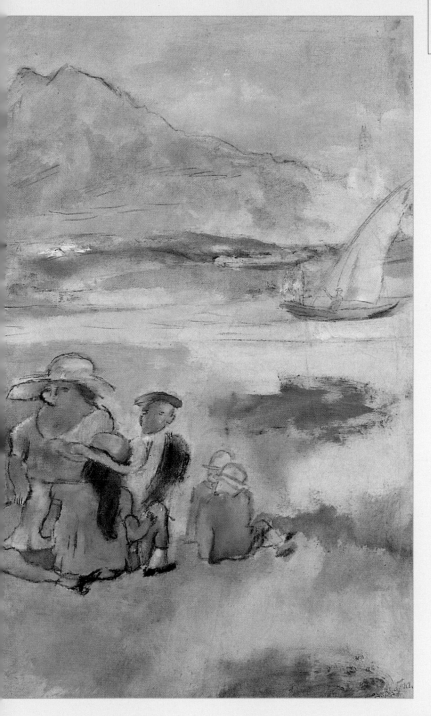

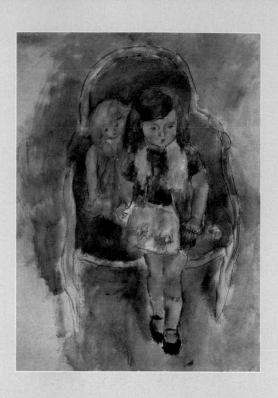

There are the humorous drawings that often sprung forth from his imagination, and then there are the studies created directly from models that would serve to support the conception of one of his paintings.

At about 11:00 in the morning, the model would arrive. Pascin did not use models from the académies, and even less so the celebrated models like Kiki, Aïcha, or Jaqueline de Montparnasse. He did not want to use those who had worked for everyone else. "The old horses" he spitefully called those models that, for him, held no emotion after the first glance. Derain, Picasso, Kisling, Krogh, and Man Ray all used them, but Pascin would not. He also did not use prostitutes anymore, preferring young

35. *Portrait of Jeanine*, 1924, oil on canvas,
 92 x 73 cm, private collection

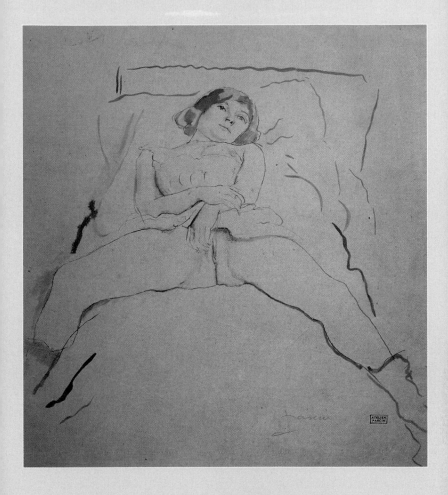

girls of the streets, and a dancer from the Palace which was not what became the famous "le Palace" nightclub of the 1970's but was one of the day's numerous music halls. Along with Van Dongen and Kisling, Pascin was one of the most generous painters, giving his models forty francs a session where other artists would only give twenty-five.

36. *Caress*, 1925, pencil drawing,
 35 x 31 cm, collection of Mr. and Mrs. Abel Rambert

At once, the girls spread the word. "Go and see Pascin… he is pleasant and he pays well…" There were often too many models, but Pascin did not choose between them. "I only love classic feminine beauty, the women of Titian for example, but when my friends discover another little worn-out oddity they send her to me. So, because she must eat like the rest of us, I invite her to pose for me like the others."[5]

After some welcoming remarks of reassurance, the new arrival would undress, slipping on a very short silk shirt that was laced up the back from the bottom. Simone might have bought this shirt the day before along with three tubes of cyan or vermilion. Sometimes there were two or three women resting on an old easy chair, always the same one. Pascin would complain that his models posed too much and desired a position of natural repose. The girls were at ease and there was always something to eat or drink. Even if they were done posing for the day, they could rest, play cards, fix something in the kitchen, amuse themselves with Simone or Mère Luce, or even sleep if they needed to. Salmon, who was a regular visitor of the studio, described it not as a harem or bordello, but more like a familial sanctuary.

Sometimes a visit would interrupt a sitting. Unforeseen visits were common in the twenties, for the telephone was a still rare commodity and artists were difficult to get in touch with. If it was a collector or a dealer, the interruption did not last long because there was never any negotiation. The cost of Pascin's paintings was determined by the size of the canvas. Compared to his contemporaries, Pascin's works sold high, and despite this, there were often no paintings available. So, they would agree that a painting would be set aside for the next visit. "When you have something, let me know, and I'll buy it."

Friends like Mac-Orlan and Salmon would also come to visit.

37. *Judith and Holopherne*, 1925-1926,
 pencil and pastel drawing, 48 x 62 cm,
 collection of Mr. and Mrs. Abel Rambert

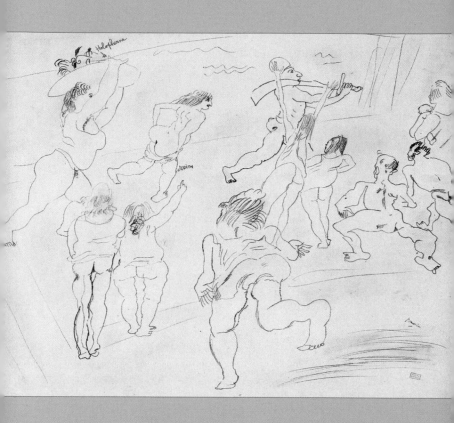

Sometimes these visits were agreeable, sometimes not. When Youki tried to exhibit her new acquisitions from Peruchia, a luxurious shoemaker, in front of Pascin's penniless models he found her behavior repellant. Pascin disliked luxury and luxurious women in every way, his preference was always for the little 'oddities.' Perhaps this was in reminiscence of the young kitchen maid in Budapest whom he had listened to and defended upon learning of the abuses of an aggressive theatre director.

Pascin preferred to work by natural light. This meant he painted until 4:00 in the summer and until 2:00 in the winter. At this rate it took two and a half days to complete a painting. At the end of a sitting, Pascin did not go out. Evenings in his household were charming and domestic with Mère Luce, Simone, Claudia, sometimes Lucy, sometimes Jaqueline, and sometimes one or two models that had stayed. If the creative demons reappeared after the meal, Pascin's hoarse voice would boom "undress yourselves" and the girls would obey gracefully and fall asleep as Pascin drew into the night.

If, as on some evenings, the demon of alcohol won out, and despite everything Lucy wanted to stay in, the annoyed Pascin would yell unjustified reproaches at her and chase her drunkenly through the studio while threatening her bodily harm. Mère Luce would become outraged, yell insults at him, and tell him to go to bed. The effect of the liquor would abate and Pascin would suddenly fall asleep like a child. Even the Grand Caliph is not master of his house every day.

38. *Venus from behind*, 1925-1928, oil on canvas,
 81 x 65 cm, gift of Mrs. Hermine David in 1936,
 Museum of Modern Art, Paris

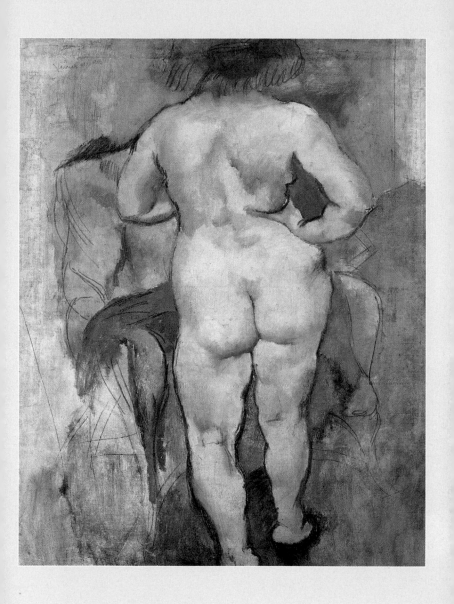

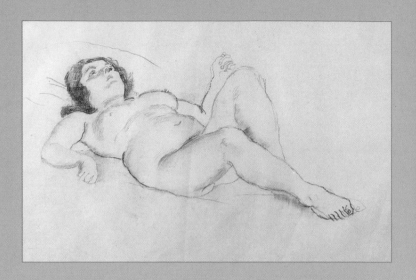

Sometimes he would come home around two or three in the morning and take up his work again with no desire to sleep. On occasional nights he would work on an engraving, only printing one proof, and on others obscene drawings would flow from his imagination onto the page.

The studio was a regular venue for both intimate and extravagant parties. Kisling organized lunches every Wednesday, and Pascin was in charge of Saturday dinner, bringing together at least fifteen people who drank to their content to end up exhausted in the Montmartre bars that Pascin loved and knew like the back of his hand. If not, his circle would assemble at his studio, they would go out, and Pascin would invite them to go to the restaurants and cabarets of the neighbourhood, invariably picking up all the checks along the way.

39. *Nude Lying down*, 1926-1929, charcoal,
 32.5 x 49 cm, Israel Museum, Jerusalem

40. *Woman before a Mirror*, 1927,
 pencil and pastel drawing, 62 x 49 cm,
 collection of Mr. and Mrs. Alain Philippe Rambert

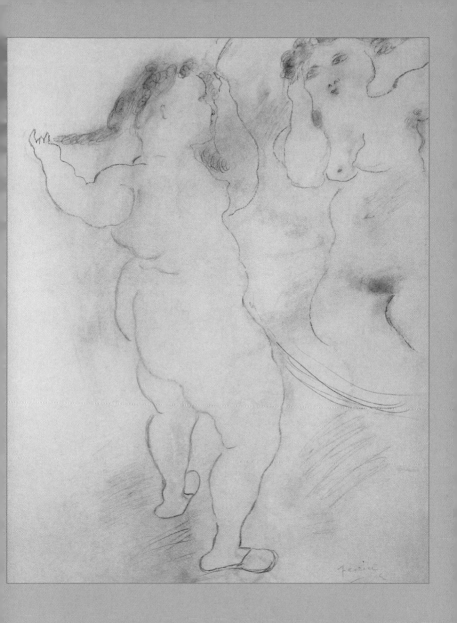

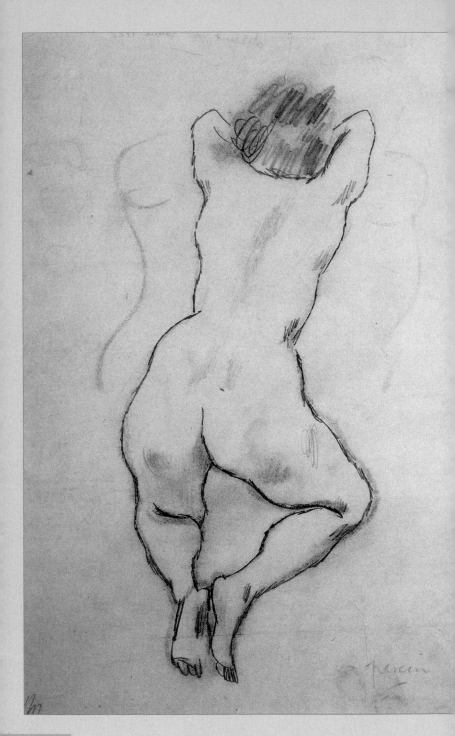

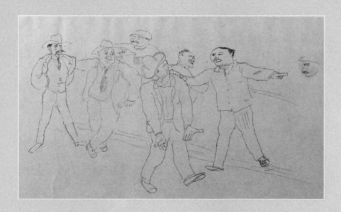

Other evenings, those that Lucy called the "noubas" would bring together almost two hundred people. The evening before, Simone would go down the stairs of the building floor by floor to ring the doorbells of all the apartments and warn the occupants who would usually abandon the building with discontent. The space would be free, and around midnight the party would hit its peak. After speaking with the master of ceremonies, one could meet the artist's "family" which consisted of Lucy, Claudia, Julie, Simone, and Hermine as well as Suzanne Valadon, Charlotte Gardel, Kiki, Youki, Jaqueline, Zinah, Aïcha. There were also the men and couples: Pierre Mac-Orlan, the Salmons, Man Ray, Derain, Papazoff, and Marcel Sauvage who all formed the "Fanfare of Montmartre" equipped with their homemade "bigophones" that were various instruments made from brass and cardboard. Rounding out the famous entourage were the Dubreuils, the Dardels, Kars, Zadkine, Florent Fels, Paul Morand, Picabia, and other painters, artists, and writers whose names are now largely forgotten.

41. *Prayer*, 1927, charcoal, 40 x 28 cm,
 collection of Mr. and Mrs. Abel Rambert

42. *The Drunkard Sent Away*, 1928, pen-and-ink drawing,
 46 x 63.5 cm, Israel Museum, Jerusalem

Next pages:
43. *Characters*, 1928, pencil, ink and watercolour drawing,
 bequest of Doctor Girardin in 1953, Museum of Modern Art, Paris

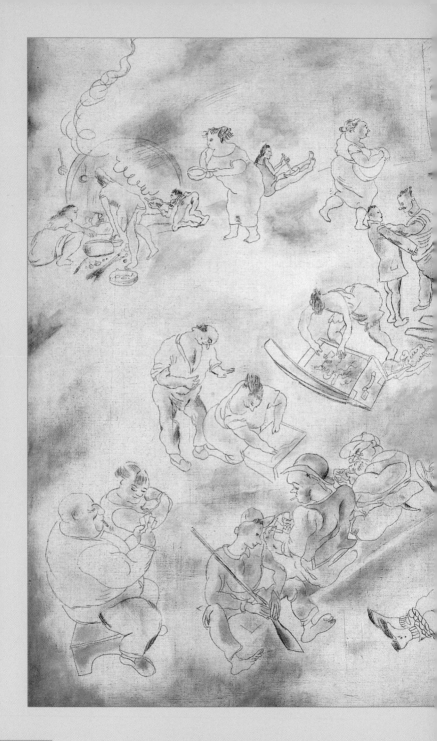

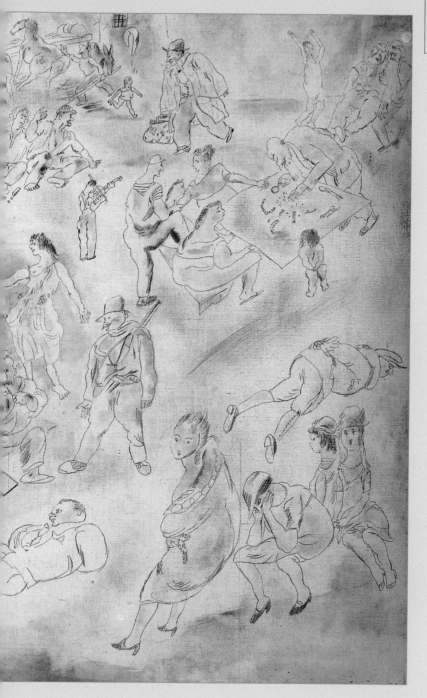

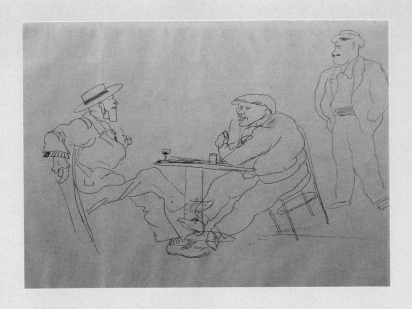

A giant stalk of bananas hung in the middle of the studio and there were tarts, and entire legs of lamb. Cases of wine, liqueurs, and cointreau were all available to the guests, resulting in all sorts of excess that usually ended happily. It was not uncommon to run across a half-dressed girl in the middle of the affected guests. To cite only one memory, one evening, the beautiful, almost too beautiful, Jaqueline de Montparnasse who Cocteau once called a "walking statue" was avoiding Kiki, also of Montparnasse, who she knew to be jealous of her relationship with Man Ray. Kiki was drunk.

They eyed each other with icy scorn. The electricity in the air excited the men, and the guests began to joke about the women's respective beauties. "You are beautiful... you are pretty," the guests joked, searching for a way to set them against one another. Kiki broke down

44. *Three Men in a Café*, 1928, pen-and-ink drawing, 44.5 x 62 cm, Israel Museum, Jerusalem

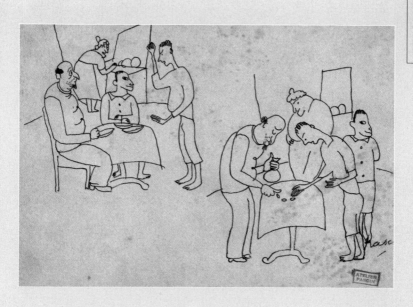

first and lashed out against Jaqueline, who did not stand defenseless. In the brawl that followed, one breast appeared and then another as the women tore each other's dresses to shreds, eventually denuding one another. Jaqueline ended up in her undergarments, and Kiki groggily staggered from the party. As Lucy was in the process of repairing Jaqueline's torn dress, the triumphant winner crossed the studio carrying a sandwich tray with panache and wearing nothing but a transparent slip. The next day the rivals crossed paths in the bar La Coupole and Kiki went before Jaqueline begging her pardon as she had been drunk. Afterwards, the two muses of Montparnasse became the best of friends.

This group of friends served as the "indispensable living material of Pascin's artistic œuvre."[6]

45. *The Young Man*, 1917, brown ink, 15.2 x 22.7 cm, private collection

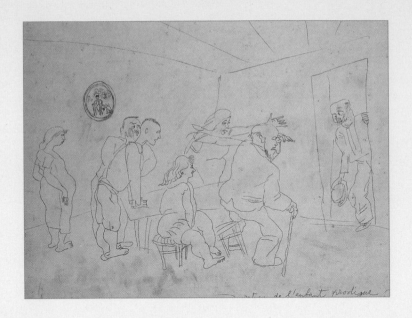

Nobody was deceived, nobody trumped his generosity or condemned his world of debauchery. The most astonishing thing about reviewing the numerous remarks about Pascin is the complicity and sincere love expressed by all of his friends who knew him and wrote about him— this list is very long. The last of his girls, Jeanine, of whom he painted a portrait when she was three years old described him as "the last incarnation of the wandering Jew that always possessed nothing, and lived like a god."[7]

The man in the bowler hat with the swaying gait walked in the ostentatious processions of his cosmopolitan tribe from Montmartre to Montparnasse, and back again. He rented villas in the suburbs on the banks of the Marne for sumptuous fêtes, where during the day the children ruled supreme, and during the night he organized his

46. *Return of the Prodigal Child*, 1928, pencil drawing, 48 x 64 cm, collection of Philippe Alexandre Rambert

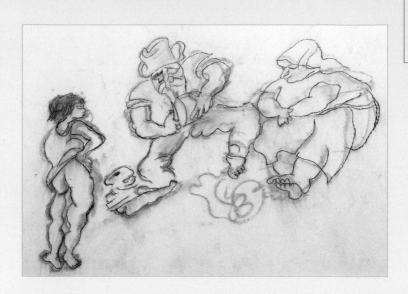

masterful "noubas" that ended in the early morning with exhausting drunken binges. In his infatuation "with the fête" Pascin was able to return to the dreams of his youth and of Fanoriatal.

Some of the drinks and disguises transported him to the Orient, shining from the middle of a harem worthy of the *Thousand and One Nights*, and visited by Eros and Venus, descended directly from their Olympus. Pascin lived a dream awake. Mac-Orlan called him "the freest man in the world, held only to this sphere by imaginary ties."[8] This chaotic harem can be found in some of Pascin's drawings and paintings where dozens of characters spring forth from every side of the composition. They are evanescent and anarchic, but each seems to have a secret role that only the director of the work understands the meaning of.

47. *Father of the Family Cutting the Bread*, 1928,
 pencil and chalk drawing, 44.5 x 63 cm,
 Israel Museum, Jerusalem

Some disappointed reactionaries, like those who burned the libertine works of Degas or Gauguin, only saw Pascin as an erotomane, a sex maniac, or a pornographer. However much he may have been one, he was not always so, and it is truly to fail to appreciate the whole of his output as based in a desire to confine himself to the depiction of vice. What would one say of the list of artists which in its entirety is interminable—the Austrians Klimt and Schiele, the Dutch Rembrandt and Rubens, the Spaniards Goya and Picasso, the English Rowlandson as well as the Frenchmen Boucher, Courbet, Rodin and Toulouse-Lautrec?

As for all of these artists, sexuality plays an integral part in the oeuvre of Pascin, although it often only represents a small part. Like Picasso, Pascin at first confined his fantasies to paper, covering the sheet with living characters and the radiant chaos of scintillating eroticism.

For Picasso it was the Minotaur, for Pascin it was Salomé, Venus, and the Amazons. His works reveal a perpetual Sabbath devoted to feverish activity where mythical characters both Greek and biblical revolt against hypocritical puritan oppression with the aid of sex.

48. *Elisabeth Stretched Out*, 1928,
 pastel drawing, 49.5 x 65.5 cm,
 Israel Museum, Jerusalem

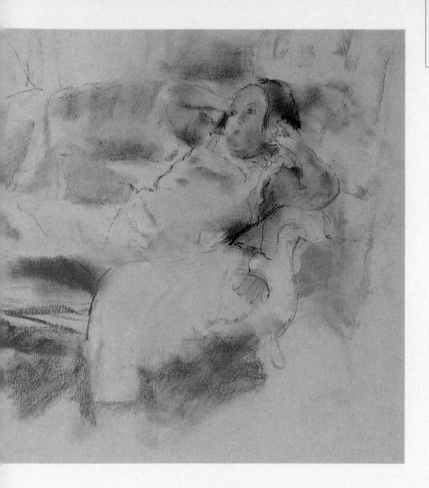

But, as it often is for those in art, sex is only skin-deep if it is the sole interest: a momentary point of obsession, sometimes only a release, an early morning ejaculation of nocturnal fantasies issued from an exhausting night stricken by creative fever or alcohol.

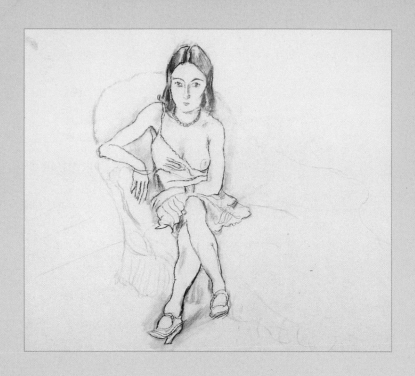

It is interesting to note that during the same early hours, only a few hundred meters away in the same silence of the Parisian night, another erotomane of no lesser degree, Pierre Louÿs set his purple ink flowing for his own pleasure upon a bulky sketchbook, liberating his perverse fantasies often set in an imaginary Parisian underworld. His prolific divertissements ranged from the theatrical adaptation *Aphrodite*, to the literature of *La Femme et le Pantin*, and an erudite study on Corneille. Without wanting to always connect the two artists, Picasso again comes to mind when discussing Pascin's prolific nature. Still, many art critics do not hesitate to present the two as "the two most astonishing

49. *Pauline*, 1928, charcoal, 48 x 65 cm,
 Israel Museum, Jerusalem

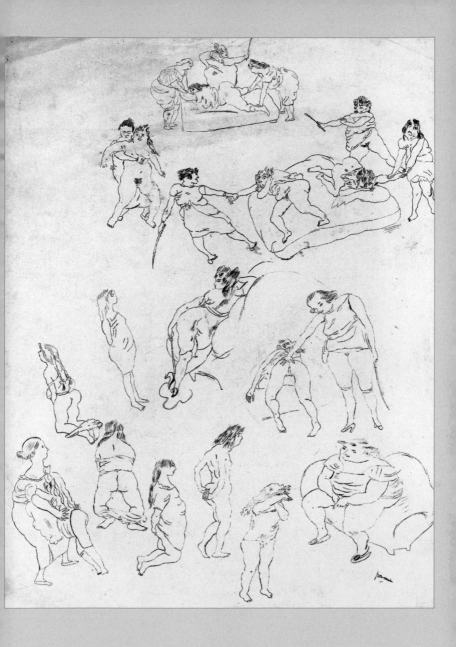

50. *Extract of a page of studies*, 1927, pencil, private collection

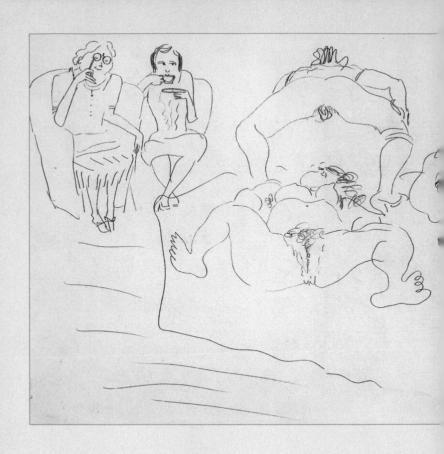

draughtsmen of our time."[9] It seems that Pascin could not stop his hand from drawing everywhere he went, whether travelling, in the street, in a restaurant or café, at home, whether night or day. His pencil captured movement, gesture and attitude without limiting or defining. His lines are short, quivering, and free of directives and they hold a nervous vivacity that is much closer to literature than to academic orthodoxy.

51. *Tea Time*, 1928, ink, 36 x 55 cm, private collection

Superior to a photographer, his simple camera were his eyes and fingers. He froze images in time, seizing their spontaneity and brilliance. Pascin sketched without repentance or remorse the happenings and landscapes that he discovered in the course of his travels. He drew the towns, streets, animals, circus performers, bars, friends, the people he loved, and those who performed before him.

In the end, his misfortune stemmed from his greatest success—the carnal promiscuity that was attributed to him and that was ripped from him. It was the bodies of immodest young girls that he painted with such subtlety, softness and transparence. Picasso is known for his blue period and his rose period. Pascin has his "pearly period," where the vaporous colours lend a voluptuous atmosphere of calm and serenity to his canvasses. This style allowed him to live well and entertain all of his friends. It permitted him to be like his father a "Master of the House," and had the power to influence with his extravagance the lives of those close to him. Being everything but a tyrant, Pascin authoritatively dominated the crazy years, the *"civilization aphrodisiaque"* of Bergson,[10] reigning with happiness, joie de vivre, anarchy, debauchery and orgy.

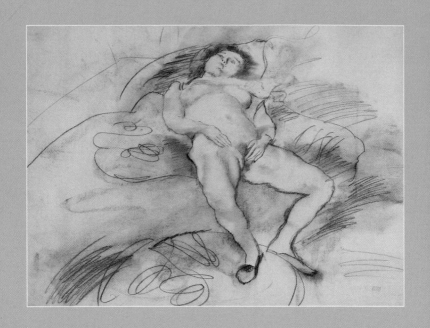

Closed up in his studio and answering the door for nobody, he would consecrate his Fridays to a canvas that would be easy to sell. On Saturday, he would quickly spend the money among the company of those who wanted to have a good time. Careless frivolity came at the expense of repetitive and prostituted work, out of a pact with the Devil. With Pascin there always existed the ambiguity of his contradictory nature. He was the Angel and the Demon, "with a look at once gentle and ferocious."[11] He was good and evil, beautiful and ugly. "I disgust myself. I defile models in my studio. I pay them for posing, but whether I sleep with them or not, I sleep with them all in the name of art, and sell them in canvas form. I have had enough of being a pimp through painting. I have had enough of good little girls in their posing blouses.

52. *Nostalgia*, 1928, pencil drawing, 47 x 62 cm,
 collection of Mr. and Mrs. Abel Rambert

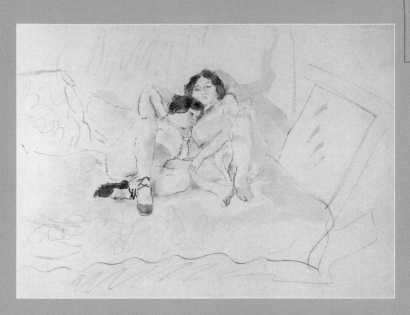

But they sell well, you understand? If only you could know how far away all of this is from the ambitions I held as a young man. I know I am finished. I am at the end of my tether, and will not be able to go on like this anymore."[12] Was Pascin the pimp, or the prostitute? In fact, he found himself prostituted by a contract from the Bernheim-Jeune gallery, owned by two often maligned brothers, to ceaselessly reproduce a single type of overworked painting, specifically, his pearly paintings. This contract came at a time when Pascin wanted to create larger canvasses teeming with his imaginary worlds. As it is for girls on the street, money earned too quickly flies away just as fast. Like the whore giving all of her profit to her pimp, in one night, Pascin, with the help of his swarming entourage of guests, would burn through the

53. *Two Women on a Bed*, 1928, watercolour, 49 x 64 cm, collection of Mr. and Mrs. Abel Rambert

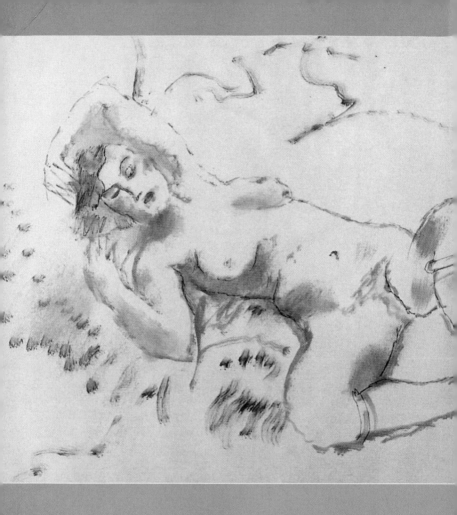

10,000 francs obtained for the painting created the night before. Pascin had signed his name and was trapped. "Don't you hate me for selling myself?" he asked his friend André Warnod the day after he signed the contract that bound him hand and foot to the Galerie

54. *Nude Lying down*, 1928-1929, pencil, ink and wash drawing, 48 x 67.5 cm, Israel Museum, Jerusalem

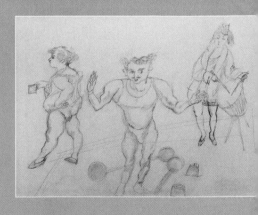

Bernheim-Jeune. Still, nobody could have been in his place to know which of his conditions were responsible for his final actions. It could have been his amorous disappointments, the state of his soul, the profound pain borne from his sharp intelligence, his extreme sensitivity, his contractual obligations, or his body exhausted by excess.

All we know for certain is that in the middle of night on June 3rd, 1930, Pascin chose in all lucidity to kill himself. Sure of his conviction he opened his veins and, finding that death took too long to come, hung himself from his door. "Despite it all, everything was in its place and the gods were content," Joseph Delteil would comment later.[13]

55. *The Travelling Artists*, 1929, ink, coloured pencils and watercolour on canvas, 44 x 64 cm, Israel Museum, Jerusalem

But to commit suicide is not to die, as Pascin continued to live on in others. He stayed in the spirit of his two "wives" and his 365 models for all of their lives. Pascin had won over Lucy until the end of her life. Neither Lucy nor Hermine remarried, staying faithful to Pascin and passing the rest of their days in keeping to his memory. Lucy believed that had she come to the apartment he would have opened the door to her and she would have been able to save him. For the rest of her life she bore the incertitude and guilt of not having been at the Boulevard de Clichy on the night before his death.

Picasso, whose life is a common point of reference to art of the twentieth-century, was born in 1881 and died in 1973. Pascin, four years his junior disappeared almost half a century earlier. What would have become of Pascin's work if he had not taken his life? He always refused to be part of any real school, or to follow any trend or "ism," and had no passion for theory on art.

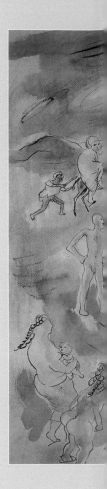

56. *The Fakir*, 1929, ink and watercolour drawing,
gift of Mrs. Hermine David and Lucy Krogh in 1936,
MNAM-CCI, Georges-Pompidou Centre, Paris

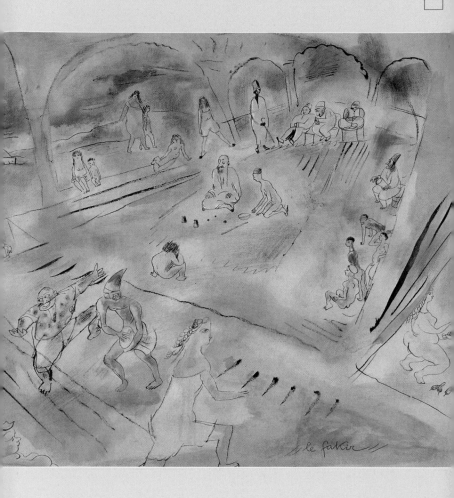

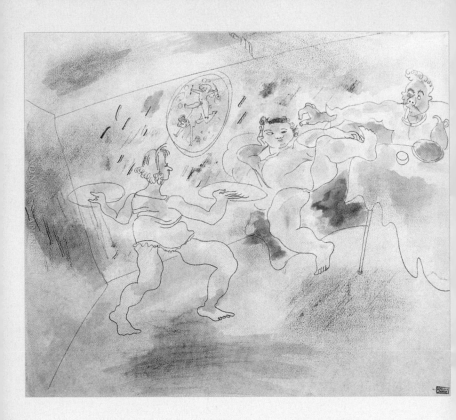

He had even tried his own hand at the *Demoiselles d'Avignon*. Would he have refused "the temptation of profit?"[14] Would he have eventually painted his own *Guernica?* Or would his works simply have been "unsellable" paintings to our eyes, forgotten and teeming with "grotesque characters from the depths of dirty colours who announce with a certain prescient manner a world beyond repair, without perspective" a work "diminished by the menaces it profiles." It is impossible to know, for Bacchus died, and the bacchanal of Montmartre born in his palette drowned in his blood.

57. *The Pleasures of Life*, 1929, pen-and-ink drawing enhanced
 with watercolour, 42 x 48 cm, Israel Museum, Jerusalem

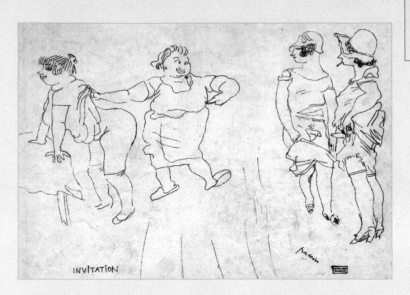

Notes

[1] André Warnod, *Pascin*. Monte-Carlo: Édition du livre, 1954.

[2] Florent Fels, *Dessin de Pascin*. Paris: Éditions du Colombier, 1966., as cited by André Bay, *Pascin*. Paris: Éditions Abel Rambert, 1980.

[3] Pierre Mac-Orlan, *L'Art Vivant*. July 1, 1930.

[4] Pascin, quoted by Pierre Dubreuil in *Pascin, œuvre gravé*. Paris: Éditions Abel Rambert, 1981.

[5] Georges Papazoff, *Pascin !... Pascin !... C'est moi !...* Paris: Pierre Cailer, 1959.

[6] Jeanine Warnod, *Le Figaro*. March 15 1976.

[7] From Pierre Mac Orlan's preface to André Warnod, *Pascin*. Monte-Carlo: Édition du livre, 1954.

[8] Here, René Barotte in the *Paris-Presse*, of Dec. 27, 1966 but again in Jean-Claude Bélier, among others, in Pascin, 1966, "jusqu'à faire de Pascin avec Picasso le plus grand dessinateur du début de ce siècle et sans doute l'un des plus importants de tous les temps."

58. *Invitation*, 1928, ink, 34.5 x 41.5 cm, private collection

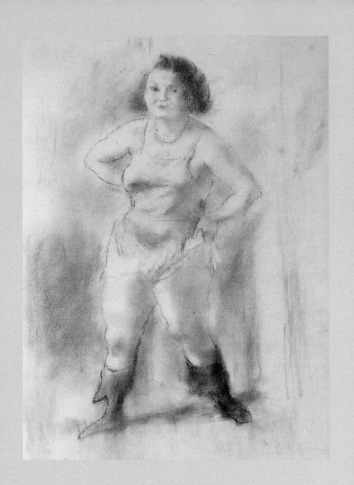

[9] Cited by André Bay, A*dieu Lucy, Le roman de Pascin*. Paris: Albin Michel, 1983.

[10] René Barotte, *Paris-Presse*, Dec. 27, 1966.

[11] Cited by Stéphan Lévy-Kuentz, *Pascin et le tourment*. Paris: Éditions de la Différence, 2001.

[12] Joseph Delteil, *L'Art Vivant* no. 145, p. 12, Feb. 1931.

[13] Yves Kobry, *Pascin* 1885-1930. p. 9, Musée-Galerie de la Seita, 1994.

[14] Yves Kobry, ibid, p. 10.

59. *Bertha in Black Stockings*, 1929, charcoal and pastel,
 62 x 46 cm, Israel Museum, Jerusalem

60. *Young Girl in Undergarments*, 1929, charcoal,
 55 x 38.5 cm, Israel Museum, Jerusalem

Index

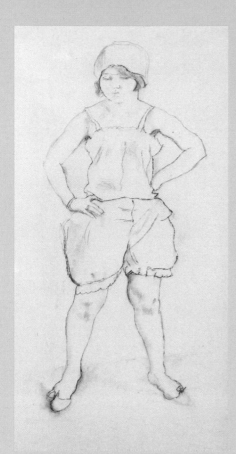

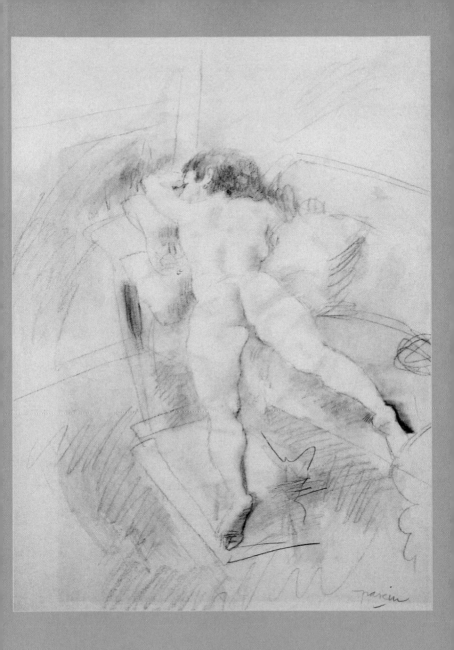

61. *Nude from behind on Settee*, 1929, charcoal,
 65 x 48.5 cm, collection of Mr. and Mrs. Abel Rambert

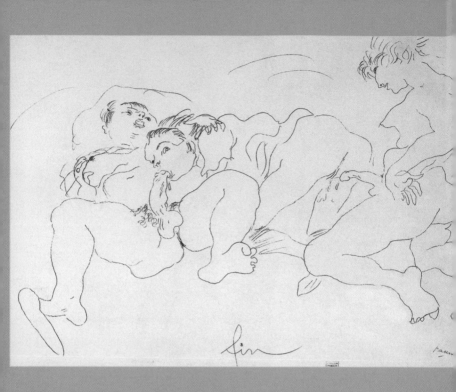

62. *With the Amazons*, End of 1928, ink, 35.5 x 54.5 cm, private collection